FROM THE FILMS OF

Harry Potter

— THE —

GOLDEN SNITCH

T0364047

RP Minis®
Hachette Book Group
1290 Avenue of the Americas, New York, NY 10104
www.runningpress.com
@Running_Press

First Edition: August 2023

Published by RP Minis, an imprint of Perseus Books, LLC, a subsidiary of Hachette Book Group, Inc. The RP Minis name and logo is a registered trademark of the Hachette Book Group.

Running Press books may be purchased in bulk for business, educational, or promotional use. For more information, please contact your local bookseller or the Hachette Book Group Special Markets Department at Special.Markets@hbgusa.com.

The publisher is not responsible for websites (or their content) that are not owned by the publisher.

ISBN: 978-0-7624-8242-9

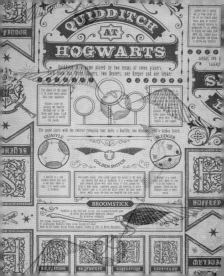

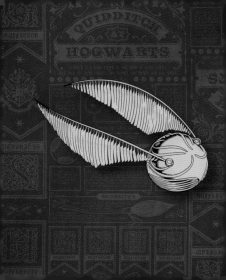

"THE ONLY THING I WANT YOU TO WORRY ABOUT IS THIS . . . THE GOLDEN SNITCH."

—Oliver Wood,
Harry Potter and the Sorcerer's Stone

THE GOLDEN SNITCH

The Golden Snitch is equal parts magic and mystery. Although the smallest Quidditch ball, the Golden Snitch is also the fastest. With a golden, aerodynamic exterior and hummingbird-like wings, it circles the Quidditch pitch at fantastical speeds, eluding the watchful eyes of players and

onlookers alike. Except, of course, for most highly skilled Seekers, like Harry Potter! Bringing the Golden Snitch to the big screen for the Harry Potter film series was no small feat either. Discover more about the Golden Snitch, its most magical movie moments, and what it took to bring these high-flying scenes to life.

✳ · ✳ · ✳

FEATURES

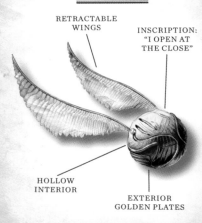

RETRACTABLE
WINGS

INSCRIPTION:
"I OPEN AT
THE CLOSE"

HOLLOW
INTERIOR

EXTERIOR
GOLDEN PLATES

RETRACTABLE
WINGS

* ✳ *

INSCRIPTION:
"I OPEN AT THE CLOSE"

* ✳ *

EXTERIOR
GOLDEN PLATES

* ✳ *

HOLLOW INTERIOR

MOVIE MAGIC: MAKING THE SNITCH

In *Harry Potter and the Sorcerer's Stone*, Golden Snitch props were created from copper and then plated with real gold. Production designer Stuart Craig explained how each Golden Snitch's wings "retract into the grooves on the sphere so that it reverts back to being just a ball." However, all the Snitch's sounds and

movements, including the retract-able wings, were created through sound effects and state-of-the-art computer graphics.

✳ • ✳ • ✳

"WHAT DO I DO WITH IT?"

—Harry Potter,
Harry Potter and the Sorcerer's Stone

SECURING THE SNITCH

A large, decorated chest stores the balls needed for the game of Quidditch, including the Quaffle, Bludgers, and—of course—the Golden Snitch! The Golden Snitch is secured within a special compartment in the lid of the chest. Referees release it from the compartment at the start of each Quidditch match.

✳ • ✳ • ✳

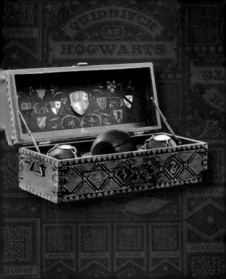

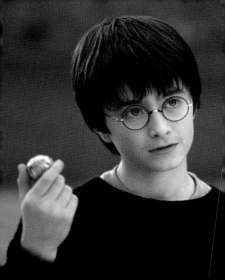

"I LIKE THIS BALL."

—Harry Potter,
Harry Potter and the Sorcerer's Stone

SNITCH SEEKERS

In *Harry Potter and the Sorcerer's Stone,* Oliver Wood explains Quidditch to Harry, including the game's basic rules, equipment, and positions. He tells the boy wizard, "You are a Seeker," an indispensable position on the Quidditch pitch. Each Quidditch team has one Seeker, and each Seeker has a single purpose: to catch the Golden Snitch. Their objective requires speed, skill, and a great deal of risk-taking. Fortunately, the position's high stakes can deliver equally high rewards. Catching the Snitch is worth 150 points.

HARRY POTTER™

07

SEEKER

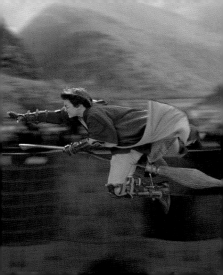

"IT'S WICKED FAST AND DAMN NEAR IMPOSSIBLE TO SEE."

—Oliver Wood,
Harry Potter and the Sorcerer's Stone

MOVIE MAGIC: WATCH CLOSELY

Did you know filmmakers gave audiences a clue to Harry's Snitch-seeking talents—even before the boy wizard had played his first Quidditch match? It's true! While Oliver Wood introduces Harry to the Golden Snitch in *Harry Potter and the Sorcerer's Stone*, the elusive orb suddenly sprouts

wings and flies into the air. Oliver immediately loses the wicked-fast ball, cluelessly searching the sky for its whereabouts. Meanwhile, Harry never loses sight of the Golden Snitch, expertly tracking the ball as it zig-zags in front of his eyes . . . a prelude of things to come.

✳ • ✳ • ✳

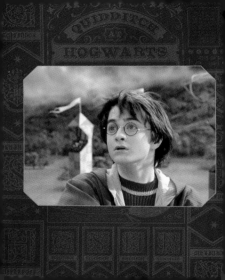

"YOU CATCH THIS, THE GAME'S OVER. YOU CATCH THIS, POTTER, AND WE WIN."

—Oliver Wood,
Harry Potter and the Sorcerer's Stone

HARRY'S FIRST "CATCH"

Harry catches his first-ever Golden Snitch during a match against Slytherin in *Harry Potter and the Sorcerer's Stone*. Instead of capturing this Golden Snitch with his hands, Harry accidentally "catches" his first game-winning Snitch with his mouth!

✳ • ✳ • ✳

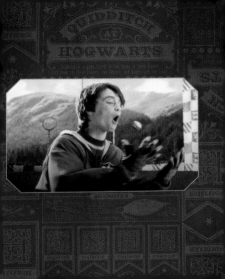

MOVIE MAGIC: TAKING FLIGHT

In the films, Harry flies atop his broomstick with ease. In reality, however, creating these high-flying movie scenes is a complicated feat. Actor Daniel Radcliffe, who played the character Harry Potter in the film series, explained the complex process. "They've got a broom with a bike saddle on it," he said in

an interview. "And I've got Velcro trousers that come apart in the middle and at the back. And they harnessed me up to the seat . . . And then we're on a green screen, obviously, or a blue screen." A hydraulic rig moves the broom while a camera circles around the actor to capture the motion. Computer graphics are added to this green-screen footage to complete the death-defying action seen on the screen.

ALL-STAR SEEKER

PLAYER: Harry Potter (07)	
TEAM Gryffindor	

The youngest Hogwarts' Seeker of the century, Harry Potter led Gryffindor to a much-awaited Quidditch Cup victory during his third year. With speed, death-defying maneuvers, and the unmatched ability to capture the Golden Snitch, Harry eventually became Gryffindor's team captain.

ALL-STAR SEEKER

PLAYER: Draco Malfoy (07)

TEAM: Slytherin

During his second year at Hogwarts, Draco Malfoy took over as Slytherin's Seeker. Draco's father, Lucius, purchased brand-new Nimbus 2001s for the entire team. These top-of-the-line brooms most certainly aided in Slytherin's success on the pitch—as well as his son's Snitch-seeking abilities.

ALL-STAR SEEKER

PLAYER:	Cedric Diggory (07)
TEAM:	Hufflepuff

A skilled Seeker and team leader for the house of Hufflepuff. During his sixth year, Cedric Diggory participated in the Triwizard Tournament, along with Harry Potter and Viktor Krum. He was killed during the third task—the Triwizard Maze—by Peter Pettigrew's Killing Curse.

ALL-STAR SEEKER

PLAYER: Viktor Krum (07)	
TEAM: Bulgarian National Quidditch Team	

A young Quidditch prodigy, Viktor Krum played professionally for the Bulgarian team during the 422nd Quidditch World Cup. The world-class Seeker competed in the Triwizard Tournament at Hogwarts, where he eventually lost to Harry Potter.

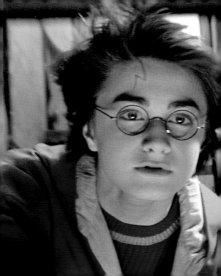

"HARRY POTTER HAS CAUGHT THE SNITCH! GRYFFINDOR WINS!"

—Lee Jordan,
Harry Potter and the Chamber of Secrets

MOVIE MAGIC:
BALL IN THE DETAILS

Designing the Golden Snitch was no small feat—despite its miniature size. In fact, Pierre Bohanna, prop designer on *Harry Potter and the Sorcerer's Stone*, described a miniature version of the Snitch as one of his most difficult creations. "I had to do a miniature Snitch for Dumbledore's office," he said. "It

was a bronze ball about the size of a large pea that I acid-etched with a magnifying glass. Sometimes it can be just as much work to do the tiny things as the big pieces." Professor Dumbledore's office is chockful of highly detailed creations. Can you spot this miniature Snitch?

✸ • ✸ • ✸

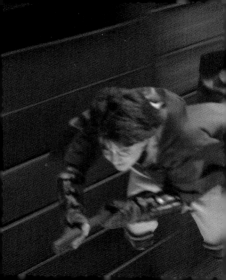

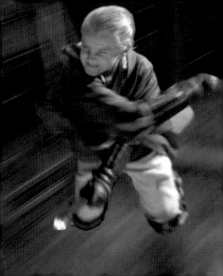

HARRY'S SECOND SNITCH

In *Harry Potter and the Chamber of Secrets*, Harry and Draco pursue the Golden Snitch during a match between rivals Hogwarts and Slytherin. During the match, a rogue Bludger injures both Seekers, but Harry eventually outmaneuvers Draco to capture the Golden Snitch, even with a broken arm.

✳ · ✳ · ✳

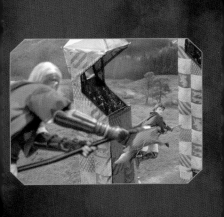

MOVIE MAGIC:
HIDDEN SNITCHES

The Golden Snitch is a key part of the
Harry Potter films. Demonstrating
its importance in the wizarding
world, filmmakers integrated Golden
Snitches into background props, set
design, and Quidditch equipment
and insignias. In *Harry Potter and the
Sorcerer's Stone*, Harry, Hermione,
and Ron check out a Hogwarts

trophy case, discovering Harry's father was a decorated Seeker. For a brief moment, eagle-eyed watchers can spot several other trophies displayed within the case, including an unidentified award of a Quidditch player flying atop . . . a Golden Snitch. Can you spot other "hidden Snitches" in the Harry Potter films?

A PARTING GIFT

In *Harry Potter and the Deathly Hallows—
Part 1,* Rufus Scrimgeour presents Harry,
Hermione Granger, and Ron Weasley with
items from Professor Albus Dumbledore's
will. Harry receives the first Golden Snitch
he ever caught, which, Dumbledore says
in his will, is "a reminder of the rewards of
perseverance and skill."

✳ • ✳ • ✳

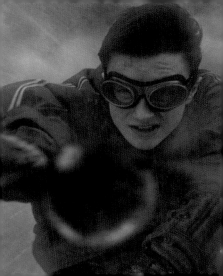

"HERMIONE, YOU WERE RIGHT. SNITCHES HAVE FLESH MEMORIES. BUT I DIDN'T CATCH THE FIRST SNITCH WITH MY HAND. I ALMOST SWALLOWED IT."

—Harry Potter,
Harry Potter and the Deathly Hallows—Part 1

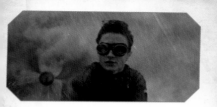

SNITCH MEMORY

In *Harry Potter and the Deathly Hallows—Part 1*, Harry presses his lips to the Golden Snitch while in the Forest of Dean. The Golden Snitch's flesh memory recognizes Harry's touch and reveals an enchanted inscription from Professor Dumbledore: "I Open at the Close."

This book has been bound using handcraft methods and Smyth-sewn to ensure durability.

Designed by Justine Kelley.